**If found, please return to:**

_____

_____

_____

_____

Published by Blue Crow Media
London, United Kingdom
bluecrowmedia.com

Copyright © Blue Crow Media 2024
All images copyright © photographers indicated
Compiled and edited by Derek Lamberton
Designed by Tuomi
Printed by Generation Press
Paper by GF Smith

ISBN 978-1-912018-06-2

Moon phases are aligned to Coordinated Universal Time.

Photo on previous page © Romain Laprade

# modernist
# weekly
# planner
# 2025

# December–January

---

**30**
Mon ●

---

**31**
Tue

---

**1**
Wed

---

**2**
Thu

---

**3**
Fri

---

**4**
Sat

---

**5**
Sun

Haus Auerbach
Walter Gropius with Adolf Meyer, 1924
Jena, Germany
© Michel Figuet (DACS)

# January

**6**
Mon ◑

**7**
Tue

**8**
Wed

**9**
Thu

**10**
Fri

**11**
Sat

**12**
Sun

Rietveld Schröderhuis
Gerrit Rietveld, 1924
Utrecht, Netherlands
© Stijn Poelstra

# January

**13**
Mon        ○

**14**
Tue

**15**
Wed

**16**
Thu

**17**
Fri

**18**
Sat

**19**
Sun

Bauhaus Meisterhaus Kandinsky/Klee
Walter Gropius, 1925–26
Dessau, Germany
© Matthias Heiderich (DACS)

# January

**20**
Mon

**21** ◑
Tue

**22**
Wed

**23**
Thu

**24**
Fri

**25**
Sat

**26**
Sun

Villa E-1027
Eileen Gray, Jean Badovici, 1926–29
Roquebrune-Cap-Martin, France
© Benjamin Gavaudo (CMN/Scala)

**27**
Mon

**28**
Tue

**29** ●
Wed

**30**
Thu

**31**
Fri

**1**
Sat

**2**
Sun

Villa Noailles
Robert Mallet-Stevens, 1927
Hyères, France
© Romain Laprade

# February

**3**
Mon

**4**
Tue

**5**          ◑
Wed

**6**
Thu

**7**
Fri

**8**
Sat

**9**
Sun

Barcelona Pavilion, Ludwig Mies
van der Rohe, Lilly Reich, 1929
Barcelona, Spain
© Gili Merin

# February

**10**
Mon

**11**
Tue

**12**     ○
Wed

**13**
Thu

**14**
Fri

**15**
Sat

**16**
Sun

Stockholm Stadsbibliotek
Gunnar Asplund, 1924–28
Stockholm, Sweden
© Federico Covre

**17**
Mon

**18**
Tue

**19**
Wed

**20**  ◑
Thu

**21**
Fri

**22**
Sat

**23**
Sun

Paimio Sanatorium
Alvar and Aino Aalto, 1929–33
Paimio, Finland
© Felix Matschke

**24**
Mon

**25**
Tue

**26**
Wed

**27**
Thu

**28** ●
Fri

**1**
Sat

**2**
Sun

Villa Cavrois
Robert Mallet-Stevens, 1929–32
Croix, France
© Romain Laprade

# March

**3**
Mon

**4**
Tue

**5**
Wed

**6**  ◑
Thu

**7**
Fri

**8**
Sat

**9**
Sun

Villa Tugendhat, Ludwig Mies
van der Rohe, Lilly Reich, 1929–30
Brno, Czech Republic
© Mary Gaudin

**10**
Mon

**11**
Tue

**12**
Wed

**13**
Thu

**14**          ○
Fri

**15**
Sat

**16**
Sun

Villa Necchi Campiglio
Piero Portaluppi, 1932–35
Milan, Italy
© Stefan Giftthaler

Villa Winternitz
Adolf Loos and Karel Lhota, 1932
Prague, Czech Republic
© Tomáš Souček

# March

**17**
Mon

**18**
Tue

**19**
Wed

**20**
Thu

**21**
Fri

**22**   ◑
Sat

**23**
Sun

Huis Sonneveld
Brinkman & Van der Vlugt, 1933
Rotterdam, Netherlands
© Marina Denisova

# March

**24**
Mon

**25**
Tue

**26**
Wed

**27**
Thu

**28**
Fri

**29** ●
Sat

**30**
Sun

Isokon Building/Lawn Road Flats
Wells Coates, 1934
London, UK
© Åke E:son Lindman

## 31
Mon

## 1
Tue

## 2
Wed

## 3
Thu

## 4
Fri

## 5
Sat ◑

## 6
Sun

De La Warr Pavilion
E. Mendelsohn, S. Chermayeff, 1935
Bexhill-on-Sea, UK
© Nigel Green

**7**
Mon

**8**
Tue

**9**
Wed

**10**
Thu

**11**
Fri

**12**
Sat

**13**
Sun

○ Montecatini Train Station, First Class
Waiting Room, A. Mazzoni, 1937
Montecatini Terme, Italy
© Adam Stěch

# April

**14**
Mon

**15**
Tue

**16**
Wed

**17**
Thu

**18**
Fri

**19**
Sat

**20**
Sun

2 Willow Road
Ernő Goldfinger, 1939
London, UK
© James O. Davies (National Trust)

# April

**21**
Mon ◑

**22**
Tue

**23**
Wed

**24**
Thu

**25**
Fri

**26**
Sat

**27**
Sun ●

Villa Stenersen
Arne Korsmo, 1937–39
Oslo, Norway
© Åke E:son Lindman

**28**
Mon

**29**
Tue

**30**
Wed

**1**
Thu

**2**
Fri

**3**
Sat

**4**
Sun

◑ 4th of May Dormitory
Hans Hansen, 1951
Frederiksberg, Denmark
© Laura Stamer

**5**
Mon

**6**
Tue

**7**
Wed

**8**
Thu

**9**
Fri

**10**
Sat

**11**
Sun

The Box
Ralph Erskine, 1941–42
Lissma (rebuilt in Lovön), Sweden
© Åke E:son Lindman

**12**
Mon ○

**13**
Tue

**14**
Wed

**15**
Thu

**16**
Fri

**17**
Sat

**18**
Sun

Finn Juhl House
Finn Juhl, 1942
Charlottenlund, Denmark
© Henrik Sørensen (F. J. House)

# May

**19**
Mon

**20**     ◑
Tue

**21**
Wed

**22**
Thu

**23**
Fri

**24**
Sat

**25**
Sun

Palace of Serbia/SIV, Potočnjak,
Ulrich, Neumann, Perak, Janković
1947–62, Novi Beograd, Serbia
© Romain Laprade

**26**
Mon

**27**
Tue                                           ●

**28**
Wed

**29**
Thu

**30**
Fri

**31**
Sat

**1**
Sun

Muuratsalo Experimental House
Alvar Aalto, 1952–54
Muuratsalo, Lake Päijänne, Finland
© Federico Covre

# June

**2**
Mon

**3**
Tue

**4**
Wed

**5**
Thu

**6**
Fri

**7**
Sat

**8**
Sun

Palazzo INA
Piero Bottoni, 1953–58
Milan, Italy
© Stefan Giftthaler

# June

**9**
Mon

**10**
Tue

**11**     ○
Wed

**12**
Thu

**13**
Fri

**14**
Sat

**15**
Sun

Ústí nad Labem City Hall, Jan Gabriel,
Jiří Fojt and Jiří Nenadál, 1956–61
Ústí nad Labem, Czech Republic
© Adam Stěch

# June

**16**
Mon

**17**
Tue

**18**  ◐
Wed

**19**
Thu

**20**
Fri

**21**
Sat

**22**
Sun

Istituto Italiano di Cultura C.M. Lerici
Gio Ponti, 1954
Stockholm, Sweden
© Federico Covre

# June

**23**
Mon

**24**
Tue

**25** ●
Wed

**26**
Thu

**27**
Fri

**28**
Sat

**29**
Sun

Wien Museum, Office of the Director
Oswald Haerdtl, 1954–59
Vienna, Austria
© Adam Stěch

**30**
Mon

**1**
Tue

**2** ◐
Wed

**3**
Thu

**4**
Fri

**5**
Sat

**6**
Sun

Bevin Court, B. Lubetkin,
F. Skinner and D. C. Bailey, 1954
London, UK
© Roberto Conte

# July

**7**
Mon

**8**
Tue

**9**
Wed

**10**  ○
Thu

**11**
Fri

**12**
Sat

**13**
Sun

Eslöv Medborgarhuset
Hans Asplund, 1955–57
Eslöv, Sweden
© Tuukka Niemi

# July

**14**
Mon

**15**
Tue

**16**
Wed

**17**
Thu

**18** ◑
Fri

**19**
Sat

**20**
Sun

Landestheater Linz
Clemens Holzmeister, 1955–58
Linz, Austria
© Adam Stěch

**21**
Mon

**22**
Tue

**23**
Wed

**24**  ●
Thu

**25**
Fri

**26**
Sat

**27**
Sun

Apartment Building, Corso Italia 22
L. C. Dominioni, F. Somaini (floor)
1957–64, Milan, Italy
© Stefan Giftthaler

**28**
Mon

**29**
Tue

**30**
Wed

**31**
Thu

**1**　　　　　　　　　　　　　　◐
Fri

**2**
Sat

**3**
Sun

**4**
Mon

**5**
Tue

**6**
Wed

**7**
Thu

**8**
Fri

**9** ○
Sat

**10**
Sun

Apartment Building, Av. Paul Doumer
Anger, Puccinelli, Véder, Gianferrari
1960, Paris, France
© Romain Laprade

# August

## 11
Mon

## 12
Tue

## 13
Wed

## 14
Thu

## 15
Fri

## 16 ◑
Sat

## 17
Sun

SAS Royal Hotel
Arne Jacobsen, 1960
Copenhagen, Denmark
© Romain Laprade

**18**
Mon

**19**
Tue

**20**
Wed

**21**
Thu

**22**
Fri

**23** ●
Sat

**24**
Sun

Apartment Building in Sesto San
Giovanni, Piero Bottoni, 1962
Milan, Italy
© Stefan Giftthaler

**25**
Mon

**26**
Tue

**27**
Wed

**28**
Thu

**29**
Fri

**30**
Sat

**31**
Sun

◖ Parco dei Principi Hotel
Gio Ponti, 1962
Sorrento, Italy
© Adam Stěch

# September

**1**
Mon

**2**
Tue

**3**
Wed

**4**
Thu

**5**
Fri

**6**
Sat

○

**7**
Sun

Aalto Library
Alvar Aalto, 1965
Seinäjoki, Finland
© Felix Matschke

# September

## 8
Mon

## 9
Tue

## 10
Wed

## 11
Thu

## 12
Fri

## 13
Sat

## 14
Sun

Södra Kull
Bruno Mathsson, 1965
Tånnö, Sweden
© Åke E:son Lindman

# September

**15**
Mon

**16**
Tue

**17**
Wed

**18**
Thu

**19**
Fri

**20**
Sat

**21**
Sun

● United Nations Palace, Building E
Charlotte Perriand (chairs), 1966–71
Geneva, Switzerland
© Adam Stěch

CBR Building
C. Brodzki, M. Lambrichs, 1967–70
Brussels, Belgium
© Jeroen Verrecht (Fosbury & Sons)

# September

**22**
Mon

**23**
Tue

**24**
Wed

**25**
Thu

**26**
Fri

**27**
Sat

**28**
Sun

Apartment Building, Via Augusta
Antoni de Moragas Gallissà, 1967
Barcelona, Spain
© Oriol Gómez

**29**
Mon

**30**
Tue

**1**
Wed

**2**
Thu

**3**
Fri

**4**
Sat

**5**
Sun

Siege du PCF
Oscar Niemeyer, 1967–80
Paris, France
© Nigel Green (Niemeyer/DACS)

# October

**6**
Mon

**7** ○
Tue

**8**
Wed

**9**
Thu

**10**
Fri

**11**
Sat

**12**
Sun

Slovak Radio, S. Svetko, S. Durkovič,
B. Kissling, 1967–83
Bratislava, Slovakia
© Maciej Czarnecki

# October

**13**
Mon ◑

_____

_____

_____

**14**
Tue

_____

_____

_____

**15**
Wed

_____

_____

_____

**16**
Thu

_____

_____

_____

**17**
Fri

_____

_____

_____

**18**
Sat

_____

_____

_____

**19**
Sun

Futuro House
Matti Suuronen, 1968
Berlin, Germany
© Gili Merin

# October

**20**
Mon

**21** ●
Tue

**22**
Wed

**23**
Thu

**24**
Fri

**25**
Sat

**26**
Sun

Torres Blancas,
Francisco J. Sáenz de Oiza, 1969
Madrid, Spain
© Romain Laprade

**27**
Mon

**28**
Tue

**29** ◐
Wed

**30**
Thu

**31**
Fri

**1**
Sat

**2**
Sun

Villa Gabryš
Vladimír Kalivoda, 1969–74
Jablůnka, Czech Republic
© Adam Stěch

# November

**3**
Mon

**4**
Tue

**5** ○
Wed

**6**
Thu

**7**
Fri

**8**
Sat

**9**
Sun

Apartment Building, Piazza Leonardo
Da Vinci, Giovanni Mistretta, 1969
Milan, Italy
© Stefan Giftthaler

**10**
Mon

**11**
Tue

**12** ◑
Wed

**13**
Thu

**14**
Fri

**15**
Sat

**16**
Sun

Apartment Building, Rue Decrès
Jean Balladur, 1970
Paris, France
© Romain Laprade (ADAGP/DACS)

**17**
Mon

**18**
Tue

**19**
Wed

**20** ●
Thu

**21**
Fri

**22**
Sat

**23**
Sun

Apartment Building, Rue Amelot
Cargill, Fischer, Ploquin, 1971
Paris, France
© Romain Laprade (ADAGP/DACS)

# November

## 24
Mon

## 25
Tue

## 26
Wed

## 27
Thu

## 28 ◑
Fri

## 29
Sat

## 30
Sun

Lugdunum Museum
Bernard Zehrfuss, 1972–75
Lyon, France
© Tuukka Niemi

# December

**1**
Mon

**2**
Tue

**3**
Wed

**4** ○
Thu

**5**
Fri

**6**
Sat

**7**
Sun

Maison de Giacinto
Jean de Giacinto, 1973
Bordeaux, France
© Adam Stěch

# December

**8**
Mon

**9**
Tue

**10**
Wed

**11**  ◑
Thu

**12**
Fri

**13**
Sat

**14**
Sun

Villa Benkemoun
Emile Sala, 1974
Arles, France
© Romain Laprade

# December

**15**
Mon

**16**
Tue

**17**
Wed

**18**
Thu

**19**
Fri

**20** ●
Sat

**21**
Sun

Villa Ottolenghi
Carlo Scarpa, 1974–78
Bardolino, Italy
© Åke E:son Lindman

# December

**22**
Mon

**23**
Tue

**24**
Wed

**25**
Thu

**26**
Fri

**27**        ◑
Sat

**28**
Sun

Casa Axis, Antonio Segura
Pascual Genovés, 1975
Valencia, Spain
© Felipe Pantone Studio

**29**
Mon

**30**
Tue

**31**
Wed

**1**
Thu

**2**
Fri

**3** ○
Sat

**4**
Sun

Walden 7
Ricardo Bofill, 1975
Barcelona, Spain
© Åke E:son Lindman

Barcelona Pavilion, Ludwig Mies
van der Rohe, Lilly Reich, 1929
Barcelona, Spain
© Gili Merin

# 2025

## January
|   |   |   |   |   |   |   |
|---|---|---|---|---|---|---|
|   |   | 1 | 2 | 3 | 4 | 5 |
| 6 | 7 | 8 | 9 | 10 | 11 | 12 |
| 13 | 14 | 15 | 16 | 17 | 18 | 19 |
| 20 | 21 | 22 | 23 | 24 | 25 | 26 |
| 27 | 28 | 29 | 30 | 31 |   |   |

## February
|   |   |   |   |   |   |   |
|---|---|---|---|---|---|---|
|   |   |   |   |   | 1 | 2 |
| 3 | 4 | 5 | 6 | 7 | 8 | 9 |
| 10 | 11 | 12 | 13 | 14 | 15 | 16 |
| 17 | 18 | 19 | 20 | 21 | 22 | 23 |
| 24 | 25 | 26 | 27 | 28 |   |   |

## March
|   |   |   |   |   |   |   |
|---|---|---|---|---|---|---|
|   |   |   |   |   | 1 | 2 |
| 3 | 4 | 5 | 6 | 7 | 8 | 9 |
| 10 | 11 | 12 | 13 | 14 | 15 | 16 |
| 17 | 18 | 19 | 20 | 21 | 22 | 23 |
| 24 | 25 | 26 | 27 | 28 | 29 | 30 |
| 31 |   |   |   |   |   |   |

## April
|   |   |   |   |   |   |   |
|---|---|---|---|---|---|---|
|   | 1 | 2 | 3 | 4 | 5 | 6 |
| 7 | 8 | 9 | 10 | 11 | 12 | 13 |
| 14 | 15 | 16 | 17 | 18 | 19 | 20 |
| 21 | 22 | 23 | 24 | 25 | 26 | 27 |
| 28 | 29 | 30 |   |   |   |   |

## May
|   |   |   |   |   |   |   |
|---|---|---|---|---|---|---|
|   |   |   | 1 | 2 | 3 | 4 |
| 5 | 6 | 7 | 8 | 9 | 10 | 11 |
| 12 | 13 | 14 | 15 | 16 | 17 | 18 |
| 19 | 20 | 21 | 22 | 23 | 24 | 25 |
| 26 | 27 | 28 | 29 | 30 | 31 |   |

## June
|   |   |   |   |   |   |   |
|---|---|---|---|---|---|---|
|   |   |   |   |   |   | 1 |
| 2 | 3 | 4 | 5 | 6 | 7 | 8 |
| 9 | 10 | 11 | 12 | 13 | 14 | 15 |
| 16 | 17 | 18 | 19 | 20 | 21 | 22 |
| 23 | 24 | 25 | 26 | 27 | 28 | 29 |
| 30 |   |   |   |   |   |   |

## July
|   |   |   |   |   |   |   |
|---|---|---|---|---|---|---|
|   | 1 | 2 | 3 | 4 | 5 | 6 |
| 7 | 8 | 9 | 10 | 11 | 12 | 13 |
| 14 | 15 | 16 | 17 | 18 | 19 | 20 |
| 21 | 22 | 23 | 24 | 25 | 26 | 27 |
| 28 | 29 | 30 | 31 |   |   |   |

## August
|   |   |   |   |   |   |   |
|---|---|---|---|---|---|---|
|   |   |   |   |   | 1 | 2 | 3 |
| 4 | 5 | 6 | 7 | 8 | 9 | 10 |
| 11 | 12 | 13 | 14 | 15 | 16 | 17 |
| 18 | 19 | 20 | 21 | 22 | 23 | 24 |
| 25 | 26 | 27 | 28 | 29 | 30 | 31 |

## September
|   |   |   |   |   |   |   |
|---|---|---|---|---|---|---|
| 1 | 2 | 3 | 4 | 5 | 6 | 7 |
| 8 | 9 | 10 | 11 | 12 | 13 | 14 |
| 15 | 16 | 17 | 18 | 19 | 20 | 21 |
| 22 | 23 | 24 | 25 | 26 | 27 | 28 |
| 29 | 30 |   |   |   |   |   |

## October
|   |   |   |   |   |   |   |
|---|---|---|---|---|---|---|
|   |   | 1 | 2 | 3 | 4 | 5 |
| 6 | 7 | 8 | 9 | 10 | 11 | 12 |
| 13 | 14 | 15 | 16 | 17 | 18 | 19 |
| 20 | 21 | 22 | 23 | 24 | 25 | 26 |
| 27 | 28 | 29 | 30 | 31 |   |   |

## November
|   |   |   |   |   |   |   |
|---|---|---|---|---|---|---|
|   |   |   |   |   | 1 | 2 |
| 3 | 4 | 5 | 6 | 7 | 8 | 9 |
| 10 | 11 | 12 | 13 | 14 | 15 | 16 |
| 17 | 18 | 19 | 20 | 21 | 22 | 23 |
| 24 | 25 | 26 | 27 | 28 | 29 | 30 |

## December
|   |   |   |   |   |   |   |
|---|---|---|---|---|---|---|
| 1 | 2 | 3 | 4 | 5 | 6 | 7 |
| 8 | 9 | 10 | 11 | 12 | 13 | 14 |
| 15 | 16 | 17 | 18 | 19 | 20 | 21 |
| 22 | 23 | 24 | 25 | 26 | 27 | 28 |
| 29 | 30 | 31 |   |   |   |   |

# 2026

## January
|   |   |   |   |   |   |   |
|---|---|---|---|---|---|---|
|   |   |   | 1 | 2 | 3 | 4 |
| 5 | 6 | 7 | 8 | 9 | 10 | 11 |
| 12 | 13 | 14 | 15 | 16 | 17 | 18 |
| 19 | 20 | 21 | 22 | 23 | 24 | 25 |
| 26 | 27 | 28 | 29 | 30 | 31 |   |

## February
|   |   |   |   |   |   |   |
|---|---|---|---|---|---|---|
|   |   |   |   |   |   | 1 |
| 2 | 3 | 4 | 5 | 6 | 7 | 8 |
| 9 | 10 | 11 | 12 | 13 | 14 | 15 |
| 16 | 17 | 18 | 19 | 20 | 21 | 22 |
| 23 | 24 | 25 | 26 | 27 | 28 |   |

## March
|   |   |   |   |   |   |   |
|---|---|---|---|---|---|---|
|   |   |   |   |   |   | 1 |
| 2 | 3 | 4 | 5 | 6 | 7 | 8 |
| 9 | 10 | 11 | 12 | 13 | 14 | 15 |
| 16 | 17 | 18 | 19 | 20 | 21 | 22 |
| 23 | 24 | 25 | 26 | 27 | 28 | 29 |
| 30 | 31 |   |   |   |   |   |

## April
|   |   |   |   |   |   |   |
|---|---|---|---|---|---|---|
|   |   |   | 1 | 2 | 3 | 4 | 5 |
| 6 | 7 | 8 | 9 | 10 | 11 | 12 |
| 13 | 14 | 15 | 16 | 17 | 18 | 19 |
| 20 | 21 | 22 | 23 | 24 | 25 | 26 |
| 27 | 28 | 29 | 30 |   |   |   |

## May
|   |   |   |   |   |   |   |
|---|---|---|---|---|---|---|
|   |   |   |   |   | 1 | 2 | 3 |
| 4 | 5 | 6 | 7 | 8 | 9 | 10 |
| 11 | 12 | 13 | 14 | 15 | 16 | 17 |
| 18 | 19 | 20 | 21 | 22 | 23 | 24 |
| 25 | 26 | 27 | 28 | 29 | 30 | 31 |

## June
|   |   |   |   |   |   |   |
|---|---|---|---|---|---|---|
| 1 | 2 | 3 | 4 | 5 | 6 | 7 |
| 8 | 9 | 10 | 11 | 12 | 13 | 14 |
| 15 | 16 | 17 | 18 | 19 | 20 | 21 |
| 22 | 23 | 24 | 25 | 26 | 27 | 28 |
| 29 | 30 |   |   |   |   |   |

## July
|   |   |   |   |   |   |   |
|---|---|---|---|---|---|---|
|   |   | 1 | 2 | 3 | 4 | 5 |
| 6 | 7 | 8 | 9 | 10 | 11 | 12 |
| 13 | 14 | 15 | 16 | 17 | 18 | 19 |
| 20 | 21 | 22 | 23 | 24 | 25 | 26 |
| 27 | 28 | 29 | 30 | 31 |   |   |

## August
|   |   |   |   |   |   |   |
|---|---|---|---|---|---|---|
|   |   |   |   |   |   | 1 | 2 |
| 3 | 4 | 5 | 6 | 7 | 8 | 9 |
| 10 | 11 | 12 | 13 | 14 | 15 | 16 |
| 17 | 18 | 19 | 20 | 21 | 22 | 23 |
| 24 | 25 | 26 | 27 | 28 | 29 | 30 |
| 31 |   |   |   |   |   |   |

## September
|   |   |   |   |   |   |   |
|---|---|---|---|---|---|---|
|   |   | 1 | 2 | 3 | 4 | 5 | 6 |
| 7 | 8 | 9 | 10 | 11 | 12 | 13 |
| 14 | 15 | 16 | 17 | 18 | 19 | 20 |
| 21 | 22 | 23 | 24 | 25 | 26 | 27 |
| 28 | 29 | 30 |   |   |   |   |

## October
|   |   |   |   |   |   |   |
|---|---|---|---|---|---|---|
|   |   |   |   | 1 | 2 | 3 | 4 |
| 5 | 6 | 7 | 8 | 9 | 10 | 11 |
| 12 | 13 | 14 | 15 | 16 | 17 | 18 |
| 19 | 20 | 21 | 22 | 23 | 24 | 25 |
| 26 | 27 | 28 | 29 | 30 | 31 |   |

## November
|   |   |   |   |   |   |   |
|---|---|---|---|---|---|---|
|   |   |   |   |   |   | 1 |
| 2 | 3 | 4 | 5 | 6 | 7 | 8 |
| 9 | 10 | 11 | 12 | 13 | 14 | 15 |
| 16 | 17 | 18 | 19 | 20 | 21 | 22 |
| 23 | 24 | 25 | 26 | 27 | 28 | 29 |
| 30 |   |   |   |   |   |   |

## December
|   |   |   |   |   |   |   |
|---|---|---|---|---|---|---|
|   | 1 | 2 | 3 | 4 | 5 | 6 |
| 7 | 8 | 9 | 10 | 11 | 12 | 13 |
| 14 | 15 | 16 | 17 | 18 | 19 | 20 |
| 21 | 22 | 23 | 24 | 25 | 26 | 27 |
| 28 | 29 | 30 | 31 |   |   |   |

# Notes

# Notes

# Notes

# Notes

# Notes

# Notes

# Notes

# Notes

# Notes

# Notes